THE ART OF

Harry Potter™

MINI BOOK OF MAGICAL PLACES

T0052021

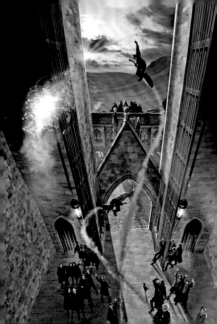

THE ART OF
Harry Potter™
MINI BOOK OF MAGICAL PLACES

Marc Sumerak

INSIGHT ◆ EDITIONS

San Rafael, California

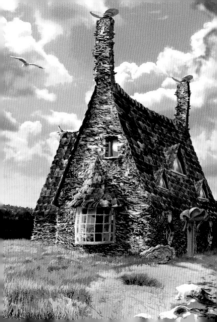

CONTENTS

AGE 2: Fred and George Weasley toss fireworks
om their brooms in artwork by Andrew Williamson
· Harry Potter and the Order of the Phoenix.

AGE 4: Concept art by Andrew Williamson for
hell Cottage for Harry Potter and the Deathly
allows – Part 2.

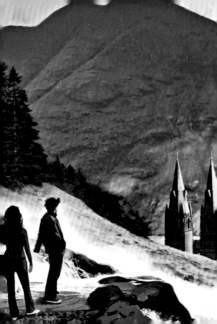

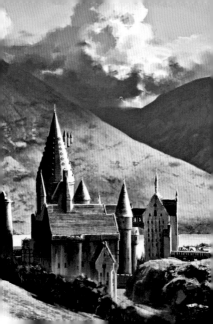

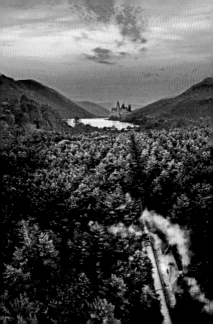

INTRODUCTION

he most wondrous thing in the
orld of the Harry Potter films
ight be the world itself. From dark
rests to ancient castles to hidden
leyways, there is magic teeming
every unique location that our
oung heroes visit. As head of the
t department, production designer

AGES 8–9: Harry and Hermione stare down at
ogwarts castle in artwork by Adam Brockbank for
arry Potter and the Goblet of Fire.

PPOSITE: Andrew Williamson depicts the
ogwarts Express approaching the castle for Harry
otter and the Half-Blood Prince.

Stuart Craig was tasked with making sure that these sensational settings didn't lose their luster as they were translated from page to screen.

Similar to most other creative aspects of the films, set designs began as a series of detailed sketches and concept art. And one of the most important sketches came not from the film's design team, but from J.K. Rowling herself.

During their first meeting to discuss the visual identity of the films, Rowling sketched out a map that told Craig everything he would need to know about Hogwarts School of Witchcraft and Wizardry. While

ot as elaborate as the Marauder's
ap, Rowling's initial sketch detailed
e most important locations of the
chool grounds—from the Front
ates to the Forbidden Forest. Craig
eld on to Rowling's sketch and
ferenced it frequently throughout
e years.

While Rowling did not provide
e concept sketches for the other
cations in the films, it was her written
ords that inspired the team of artists
orking under Craig to bring these
onic settings to life. In this book, we
ke a comprehensive tour of these
nforgettable locations via the dazzling
t that first gave them shape. Enjoy!

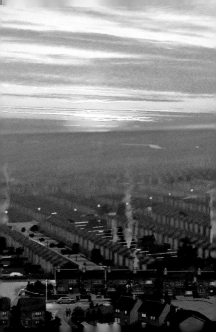

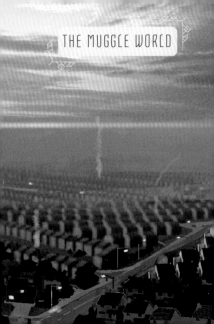

THE MUGGLE WORLD

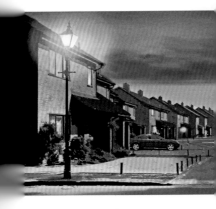

PAGES 14–15: Little Whinging at sunset by Dermot Power for the opening of *Harry Potter and the Chamber of Secrets*.

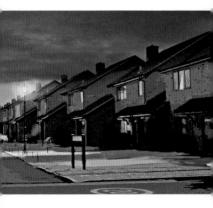

OVE: A look down Privet Drive by Andrew
iamson for *Harry Potter and the Order of the*
enix.

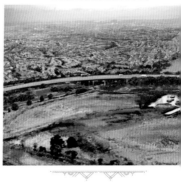

THESE PAGES: Aerial views by Andrew Williamson of the suburban neighborhood of Little Whinging for *Harry Potter and the Order of the Phoenix*.

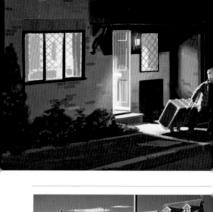
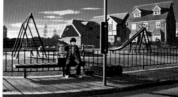

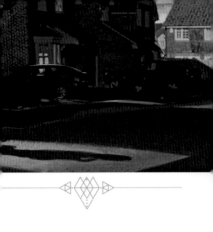

ESE PAGES: Concept art by Adam Brockbank t depicts Harry leaving the Dursley house after blows up Aunt Marge in *Harry Potter and the soner of Azkaban*.

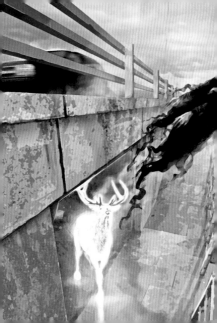

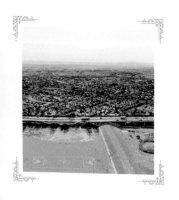

OPPOSITE: When Dementors attack Harry and
Dudley in Little Whinging in *Harry Potter and the
Order of the Phoenix*, Harry uses the Patronus
charm to repel them. Art by Andrew Williamson.

ABOVE: A hot summer day in Privet Drive.
Andrew Williamson for *Harry Potter and the Order
of the Phoenix*.

THE·HUT·ON·THE·ROCK

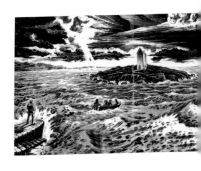

THESE PAGES: In *Harry Potter and the Sorcerer's Stone*, the Dursleys try to avoid Harry's Hogwarts acceptance letters by going to the Hut-on-the-Rock. Art by an unknown artist.

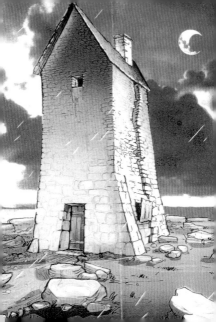

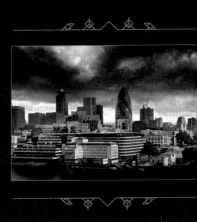

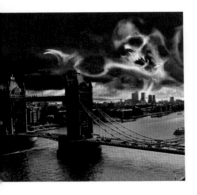

AGES 26–29: Death Eaters begin their attack
 London in *Harry Potter and the Half-Blood
ince*. Art by Andrew Williamson.

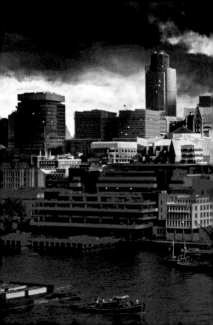

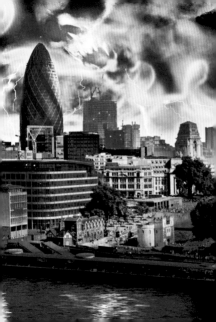

KING'S CROSS

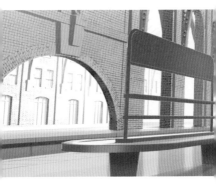

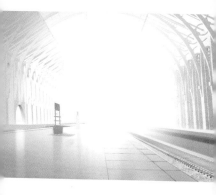

THESE PAGES: Concept art by Andrew Williamson of the ethereal King's Cross Station where Harry encounters Dumbledore in *Harry Potter and the Deathly Hallows – Part 2*.

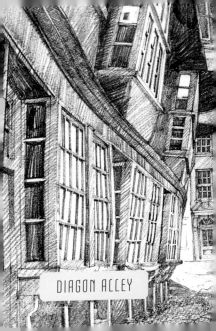

DIAGON ALLEY

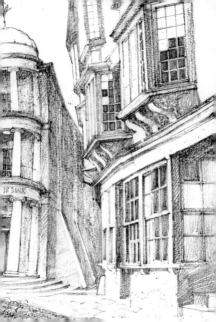

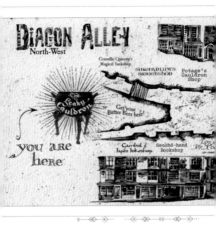

DIAGON ALLEY
North-West

Cranville Quincey's
Magical Junkshop

SUGARPLUM'S
SWEETSHOP

Potage's
Cauldron
Shop

The
Leaky
Cauldron

Get your
Butter Beer here!

you are
here

Gambol &
Japes Jokeshop

Second-hand
Bookshop

PAGES 32–33: Stuart Craig's production sketch
of Diagon Alley, one of the first sets developed
for *Harry Potter and the Sorcerer's Stone.*

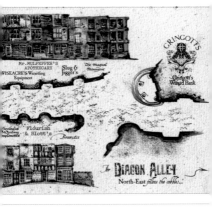

Mr. MULPEPPER'S APOTHECARY

WISEACRE'S Wizarding Equipment

The Magical Menagerie

Slug & Jiggers

Scrivenshaft's Wizarding Implements

Flourish & Blott's

Brnsntix

GRINGOTTS

Gringott's Wizard Bank

The **DIAGON ALLEY**

North-East follow the cobbles...

ESE PAGES: Map of Diagon Alley, that hangs
the wall of the Leaky Cauldron.

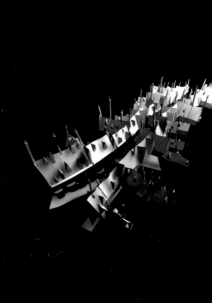

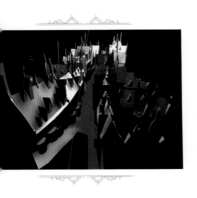

ESE PAGES: Computer-generated models
p out Knockturn Alley with its towering
mneys. Harry Potter, Ron Weasley, and
rmione Granger spy from a rooftop as Draco
lfoy enters Borgin and Burkes in *Harry Potter
d the Half-Blood Prince*.

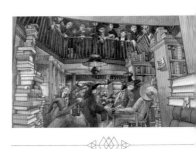

ABOVE: Artwork by Andrew Williamson of
the wizarding bookshop Flourish and Blotts,
where Gilderoy Lockhart sits for a signing of his
autobiography, *Magical Me*, in *Harry Potter and
the Chamber of Secrets*.

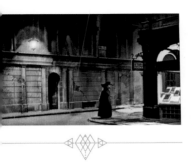

ABOVE: A witch stands outside the nondescript entrance to the Leaky Cauldron in a study by Andrew Williamson.

ABOVE: The Gringotts Wizarding Bank seal, as created by the graphics department.

OPPOSITE: In *Harry Potter and the Deathly Hallows – Part 2*, Harry, Ron, and Hermione escape from Gringotts Wizarding Bank on a Ukrainian Ironbelly dragon, as portrayed by Andrew Williamson.

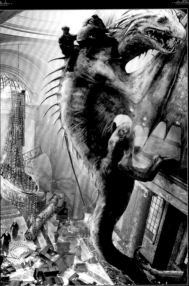

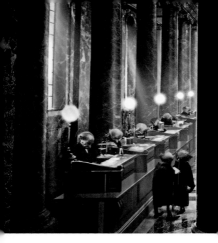

THESE PAGES: Placid views of Gringotts by
Andrew Williamson before the dragon breaks
through both floor and ceiling as it flees; both fo
Harry Potter and the Deathly Hallows – Part 2.

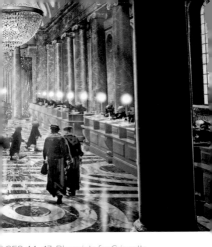

PAGES 44–47: Blueprints for Gringotts Wizarding Bank seen in *Harry Potter and the Deathly Hallows – Part 2*. A team of draftsmen and women were employed to diagram everything from buildings to brooms.

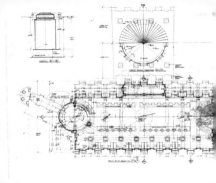

E DEATHLY HALLOWS INT GRINGOTTS BANK
ECTIONS A-A AND B-B (REVISION B)

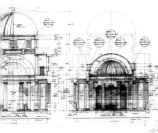

F01738

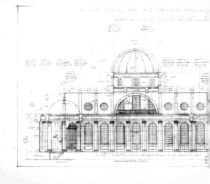

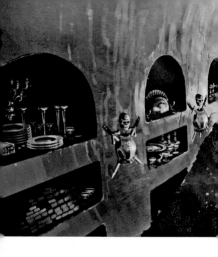

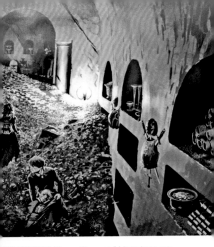

ESE PAGES: Harry, Ron, and Hermione are
ped in Bellatrix Lestrange's vault at Gringotts
gold coins and other objects multiply around
m, in *Harry Potter and the Deathly Hallows –*
t 2.

HOGWARTS CASTLE

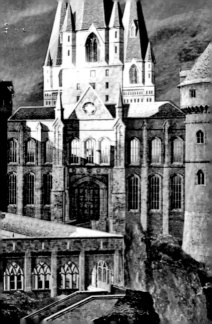

THE CASTLE EXTERIOR

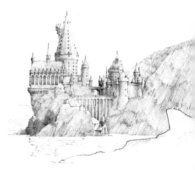

PAGES 50–51: A detailed view of the exterior of the courtyard beside the Great Hall by Andrew Williamson for *Harry Potter and the Goblet of Fir*

ABOVE: An early sketch of Hogwarts castle by production designer Stuart Craig, visual development art of Hogwarts by Dermot Power

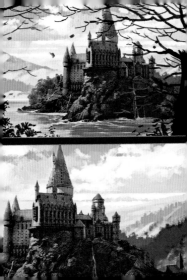

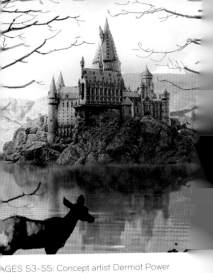

PAGES 53-55: Concept artist Dermot Power depicts Hogwarts castle from different locations in *Harry Potter and the Chamber of Secrets*.

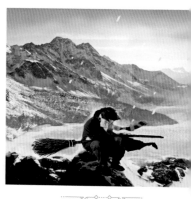

THESE PAGES: Winter scenes at Hogwarts.
Art by Adam Brockbank for *Harry Potter and the
Chamber of Secrets.*

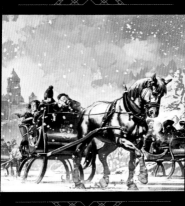

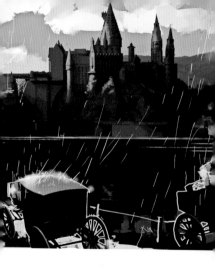

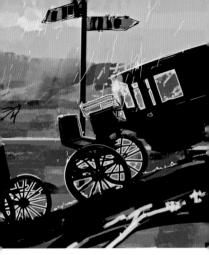

SE PAGES: Dermot Power depicts the
eless carriages carrying students to
warts on a stormy night in a scene from
/ Potter and the Prisoner of Azkaban.

PAGES 60-69: Andrew Williamson depicts the outside of Hogwarts castle from various angles in concept art developed for *Harry Potter and Prisoner of Azkaban*.

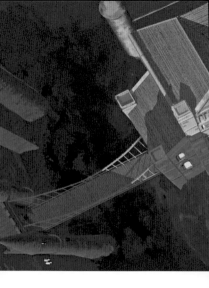

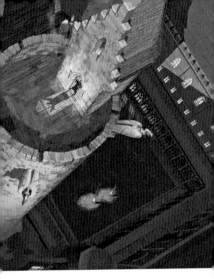

THESE PAGES: The tower in which Sirius Black
held at the end of *Prisoner of Azkaban*.

63

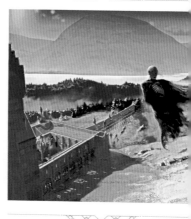

THESE PAGES: Dementors surround
Hogwarts castle.

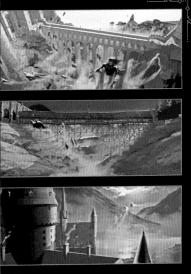

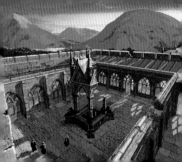

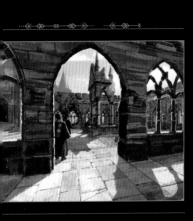

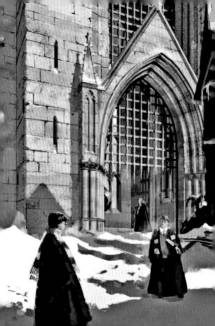

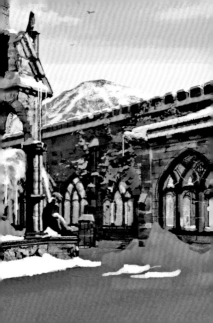

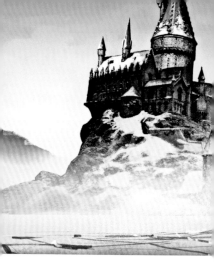

THESE PAGES: The Giant Squid bursts throug
the frozen Black Lake in a scene by Adam
Brockbank that did not make it into the films.

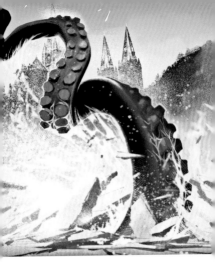

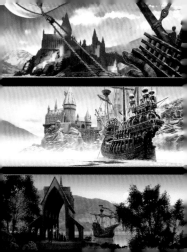

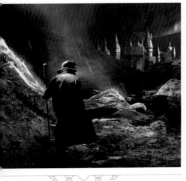

OPPOSITE: The Durmstrang ship arrives at Hogwarts. Art by Dermot Power (*top*), Adam Brockbank (*middle*), and Andrew Williamson (*bottom*).

ABOVE: "Mad-Eye" Moody arrives at Hogwarts in this piece by Andrew Williamson for *Harry Potter and the Goblet of Fire*.

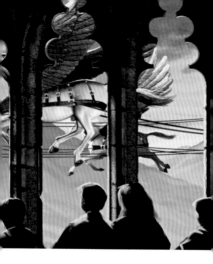

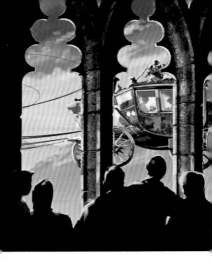

ESE PAGES: Andrew Williamson depicts the
uxbatons carriage arriving at Hogwarts for the
izard Tournament.

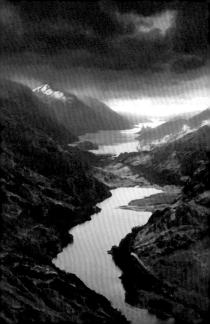

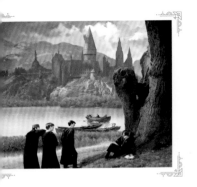

OPPOSITE: The Hogwarts Express steams through the Scottish Highlands toward Hogwarts castle in art by Adam Brockbank for *Harry Potter and the Order of the Phoenix.*

ABOVE: Andrew Williamson depicts a flashback scene that shows the Marauders confronting teenage Severus Snape in *Harry Potter and the Order of the Phoenix.*

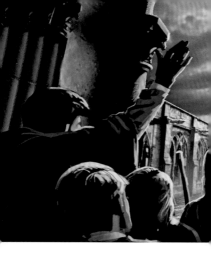

THESE PAGES: The Weasley twins escape Hogwarts on brooms as Argus Filch and other students look on. Art by Andrew Williamson for *Harry Potter and the Order of the Phoenix.*

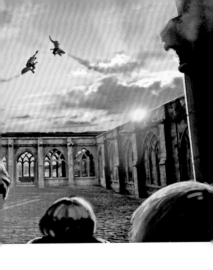

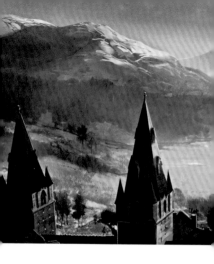

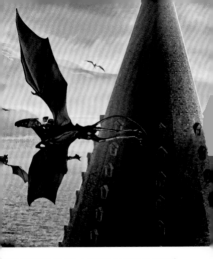

THESE PAGES: In *Harry Potter and the Order of the Phoenix*, Harry and his friends fly on Thestrals to the Ministry of Magic to rescue Sirius Black. Art by Andrew Williamson.

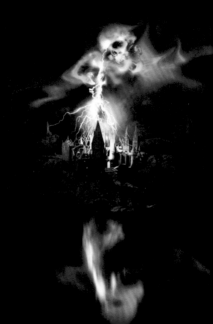

THESE PAGES: The Dark Mark hovers over
Hogwarts in these pieces by Andrew Williamson
Harry Potter and the Half-Blood Prince.

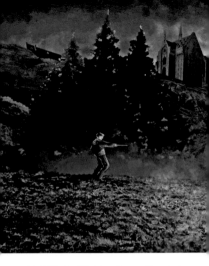

THESE PAGES: Harry faces off against
Professor Snape at the end of *Harry Potter and
the Half-Blood Prince*. Art by Andrew Williams.

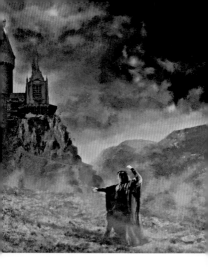

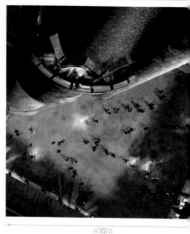

THESE PAGES: Andrew Williamson depicts Hogwarts in mourning for Professor Dumbledore in *Harry Potter and the Half-Blood Prince.*

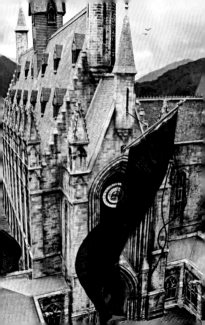

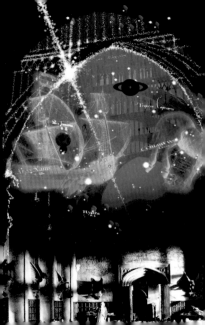

THE GREAT HALL

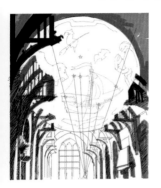

OPPOSITE: Composite of film stills and digital [...] of the Great Hall by Dermot Power.

ABOVE: Sketches by Dermot Power showing the [...]ition of the celestial globe in the bewitched [...]ng of the Great Hall.

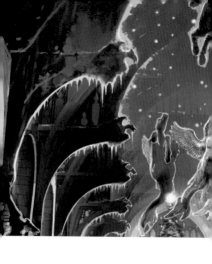

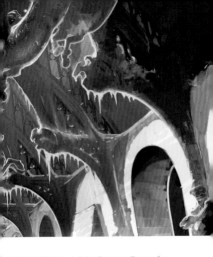

ESE PAGES: Artwork by Dermot Power for
ry *Potter and the Goblet of Fire*, showing the
ng of the Great Hall in a shot that did not
ke it into the final film.

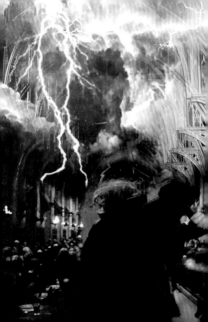

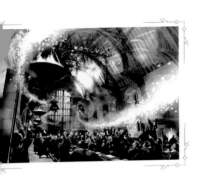

POSITE: Professor Alastor Moody makes an tric entrance into the Great Hall in *Harry Potter the Goblet of Fire* as depicted by Paul Catling.

GES 93–95: Fred and George Weasley rupt Harry's O.W.L. exams with a display of works. Art by Andrew Williamson for *Harry er and the Order of the Phoenix.*

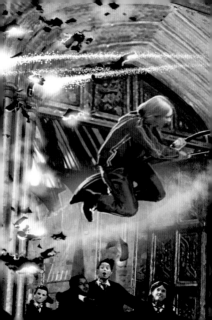

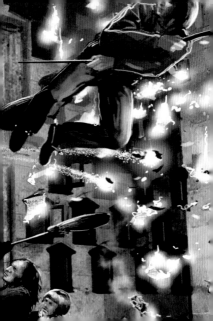

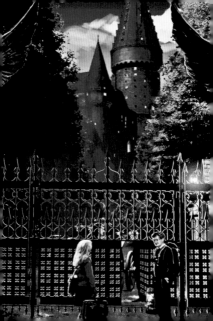

THE FRONT GATES

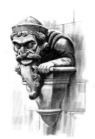

OPPOSITE: Hogwarts students are stopped at
gates of Hogwarts to be scanned for Dark
s in concept art by Andrew Williamson for
y Potter and the Half-Blood Prince.

PAGES 97–99: Gargoyle studies by Adam Brockbank.

ESE PAGES: Hermione arrives at the Yule
in *Harry Potter and the Goblet of Fire*. Andrew
iamson painted her dress periwinkle blue, as it
described in the novel.

ABOVE: Study by Andrew Williamson of the Entrance Hall with marble staircases visible in background.

OPPOSITE: Adam Brockbank illustrates Hagr and other staff members shutting up the entra to the Clock Tower.

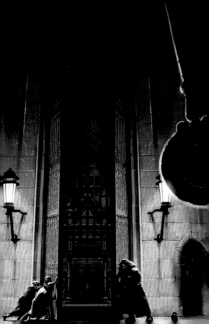

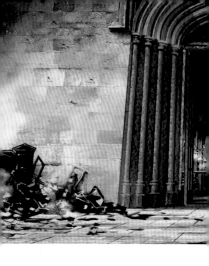

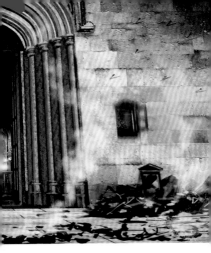

THESE PAGES: A shot of the Entrance Hall after Fred and George Weasley make their famous escape in *Harry Potter and the Order of the Phoenix*. Art by Andrew Williamson.

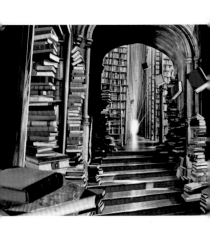

THE LIBRARY

ESE PAGES: Harry and Hermione in the
gwarts Library, complete with floating books.
work by Adam Brockbank for *Harry Potter and
Half-Blood Prince*.

PREFECTS' BATHROOM

OPPOSITE: Stained glass windows by Adam Brockbank for *Harry Potter and the Goblet of F* The mermaid resides in the Prefects' bathroom where Harry deciphers the clue for the second task. Neville Longbottom stops near the windo on the right after a difficult Defense Against the Dark Arts class.

THESE PAGES: Harry and Ron unlock the entrance to the Chamber of Secrets as Professor Lockhart looks on in *Harry Potter and the*

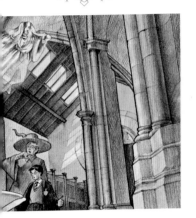

ANING MYRTLE'S BATHROOM

...mber of Secrets. Andrew Williamson floated
...aning Myrtle above the sinks, though she was
...in the scene in the movie.

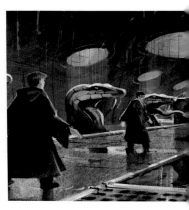

THESE PAGES: Andrew Williamson depicts th
Chamber of Secrets in art for the film of the sa
name. This piece includes Ron Weasley, who

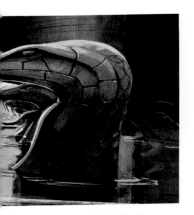

not appear in the scene in the film. Ron was ally barricaded from entering by a rockslide trapped him and Professor Lockhart.

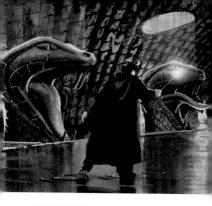

ABOVE: Another view of the Chamber by
Andrew Williamson.

RIGHT: Concept art by Andrew Williamson of
the Chamber's elaborate door.

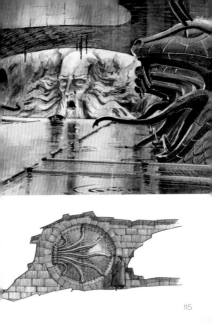

THESE PAGES: Adam Brockbank illustrates
Ron and Hermione returning to the Chamber
Secrets in *Harry Potter and the Deathly Hallow*

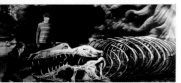

2 to retrieve a Basilisk fang to destroy a
crux. The Chamber was re-created digitally
his scene.

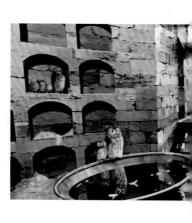

THE OWLERY

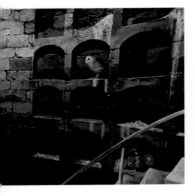

GES 118–121: Andrew Williamson portrays
erent views of the Owlery at Hogwarts. It
here that Harry encounters Cho Chang and
covers she already has a date for the Yule Ball
Harry Potter and the Goblet of Fire.

119

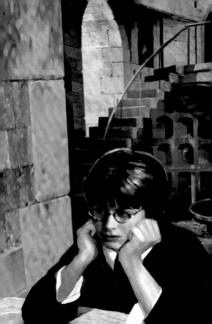

THE ROOM OF REQUIREMENT

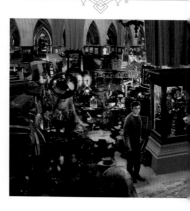

The Room of Requirement is a special room i
Hogwarts that only appears when a person ha
great need of it, coming fully equipped to ansv
that person's needs.

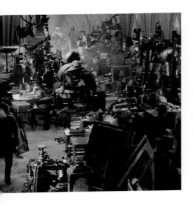

GES 122–129: Andrew Williamson depicts the
om of Requirement in its various incarnations.

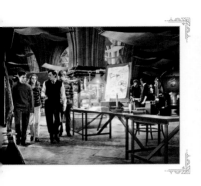

ESE PAGES: Harry, Ron, and Hermione in the
m of Requirement when Harry returned to
gwarts for the final battle, alongside a preliminary
ch showing the placement of hammocks used
e students hiding in the room.

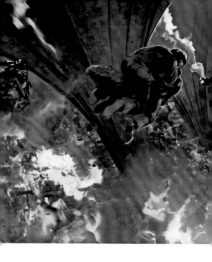

THESE PAGES: Harry, Ron, Hermione, and
Draco must escape the Room of Requirement on
brooms after Goyle releases Fiendfyre in *Harry
Potter and the Deathly Hallows – Part 2*.

THESE PAGES: Concept art by Paul Catling of the Fiendfyre that consumes the Room of Requirement in *Deathly Hallows – Part 2.*

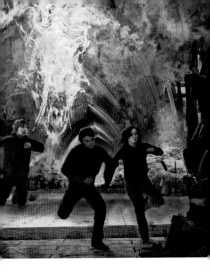

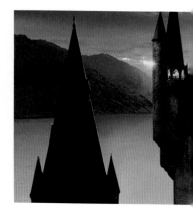

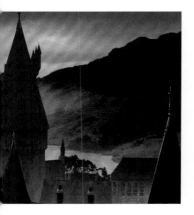

ESE PAGES: The exterior of the Astronomy
er. Art by Andrew Williamson for *Harry Potter
the Half-Blood Prince*.

PAGES 132–137: As the scene of Professor Dumbledore's tragic death, the Astronomy Tower was a major set piece in *Harry Potter and*

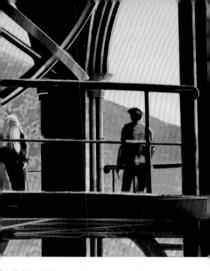

Half-Blood Prince. In these pages, Andrew [Wi]amson illustrates various views of the tower [befo]re, during, and after the climactic scene.

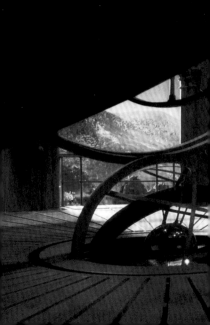

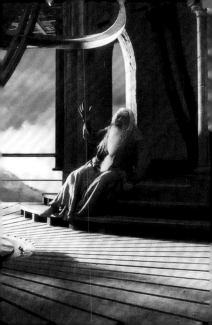

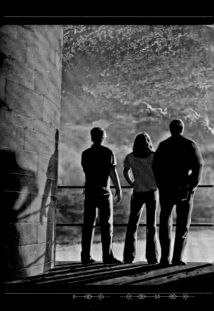

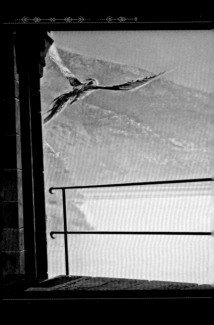

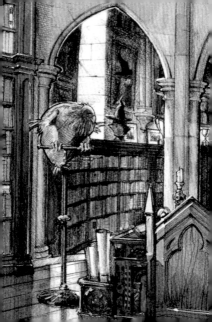

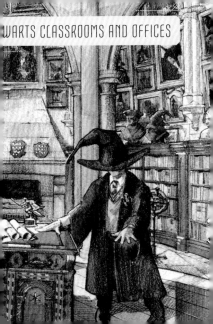

DUMBLEDORE'S OFFICE

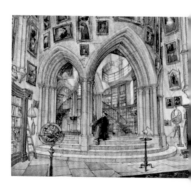

PAGES 138–140: Harry Potter awaits Professor Dumbledore in the Headmaster's office in *Harry Potter and the Chamber of Secrets*. Art by Andrew Williamson.

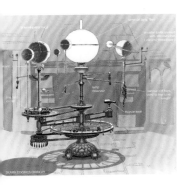

ABOVE: Adam Brockbank depicts an orrery that
in Dumbledore's office throughout the films.

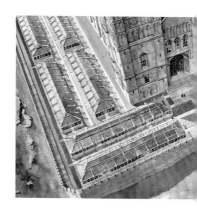

THE GREENHOUSE

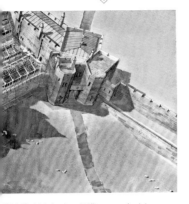

PAGES 142–144: Andrew Williamson depicts Greenhouse Three, where the second years repot Mandrakes under the tutelage of Professor Sprout in *Harry Potter and the Chamber of Secrets*.

143

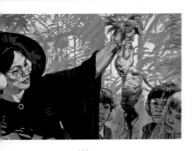

OVE: A close-up of Professor Sprout wearing
nuffs as auditory protection against the
eking Mandrakes. Artwork by Dermot Power.

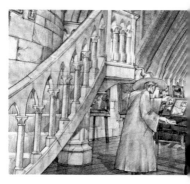

The Defense Against the Dark Arts classroom
hosted seven different teachers across the eight
films, and each teacher brought their own style
and personality to the space.

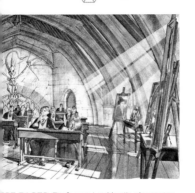

THESE PAGES: Professor Lockhart's classroom depicted by Andrew Williamson for *Harry Potter and the Chamber of Secrets*.

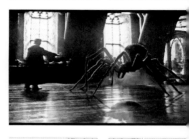

ABOVE: Dermot Power depicts the classroom during a lesson on Boggarts conducted by Professor Lupin in *Harry Potter and the Prisoner of Azkaban*.

OPPOSITE: Adam Brockbank illustrates the cabinet in which the Boggart lurks.

THESE PAGES: Professor Snape substitutes in a Defense Against the Dark Arts class when Professor Lupin is ill. These pages show the lantern projector he used to teach a lesson on werewolves. Art by Dermot Power.

THESE PAGES: In *Harry Potter and the Goblet of Fire*, Professor Moody keeps a large trunk in his offi... Unknown to Harry, this trunk includes a chamber in

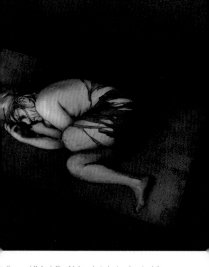

...n the real "Mad-Eye" Moody is being kept while ...mposter teaches at Hogwarts. Adam Brockbank ...ates this trunk with the captive Moody inside.

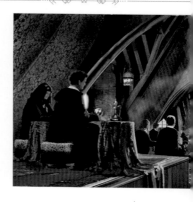

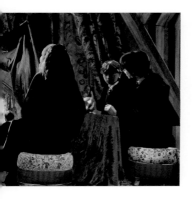

IMAGES 154–159: Concept artist Andrew
Williamson portrays Divination Professor
Trelawny's attic classroom as lavishly draped in
exotic, jewel-toned fabrics for *Harry Potter and the
Prisoner of Azkaban*.

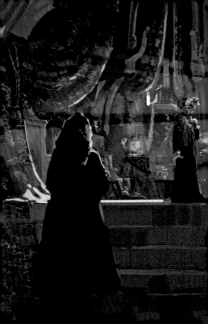

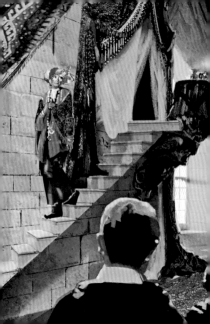

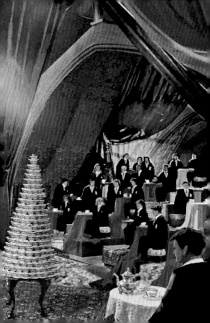

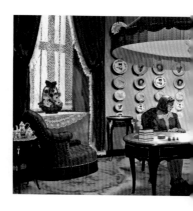

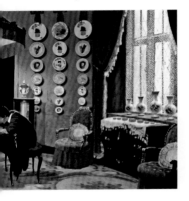

⟩SE PAGES: Professor Dolores Umbridge
⟩sees Harry's detention in her office in *Harry*
⟩*r and the Order of the Phoenix*. A study in
⟩by Adam Brockbank.

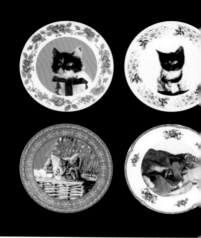

THESE PAGES: A selection of cat plates adorning Professor Umbridge's office, for whi[ch] forty different cats and kittens modeled. Digit[ally] composited by Hattie Storey.

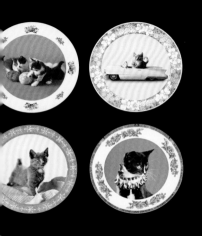

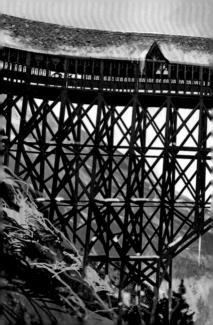

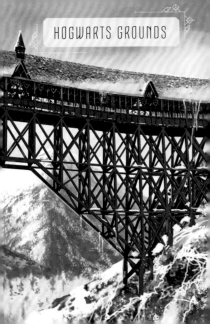

HOGWARTS GROUNDS

THE BRIDGE

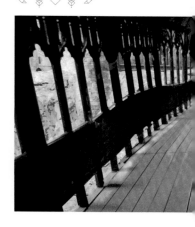

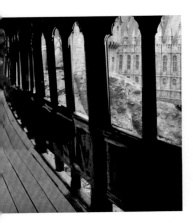

PAGES 164–167: Art by Andrew Williamson of the covered bridge and views from inside it created for *Harry Potter and the Order of the Phoenix*.

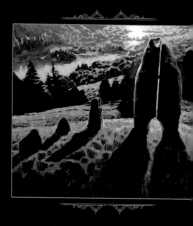

THE GATEHOUSE SUNDIAL

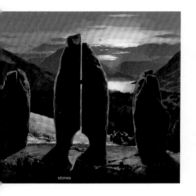

stones

THESE PAGES: Views of the Gatehouse sundial, developed by Adam Brockbank for *Harry Potter and the Order of the Phoenix*.

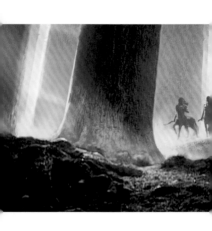

THE FORBIDDEN FOREST

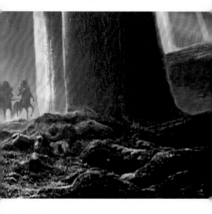

ESE PAGES: Centaurs amass in the
oidden Forest in *Harry Potter and the Order of*
Phoenix by Adam Brockbank.

171

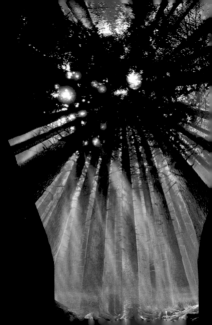

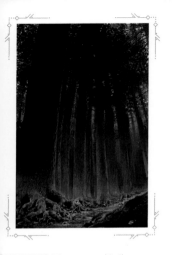

ESE PAGES: Views upward to the canopy
he Forbidden Forest by Andrew Williamson
Harry Potter and the Order of the Phoenix
wcase shadows and beams of light.

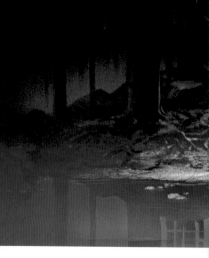

THESE PAGES: Adam Brockbank depicts the
scene where Harry finds Sirius at the edge of the

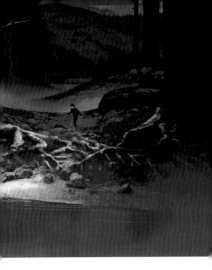

in the Forbidden Forest in *Harry Potter and the ...oner of Azkaban*.

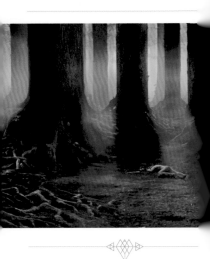

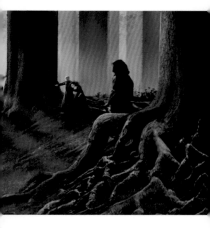

SE PAGES: Voldemort and his Death Eaters
und Harry's fallen body in *Harry Potter and the
hly Hallows – Part 2* after the Dark Lord casts
illing Curse at him. Art by Andrew Williamson.

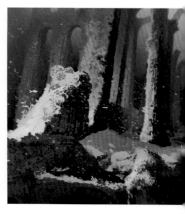

PAGES 178–183: Adam Brockbank's concept of Harry and Fleur Delacour, the Beauxbatons champion, swimming past ruins and kelp dur

THE BLACK LAKE

second task of the Triwizard Tournament in
y Potter and the Goblet of Fire.

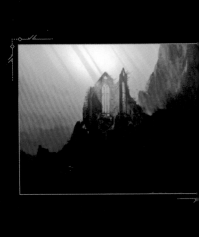

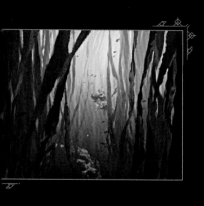

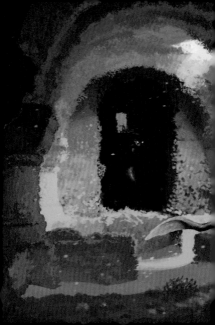

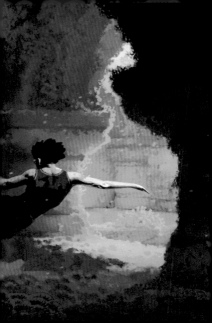

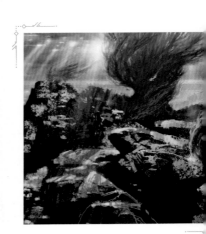

PAGES 184–189: Dermot Power offers
underwater vistas of Harry trying to find what h[e]
needs to retrieve in order to win the second tas[k]

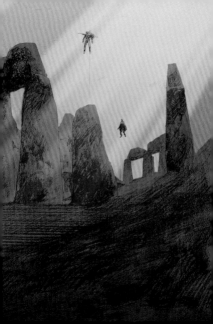

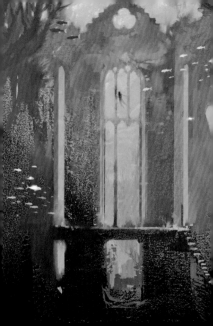

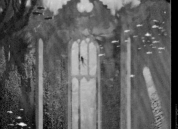

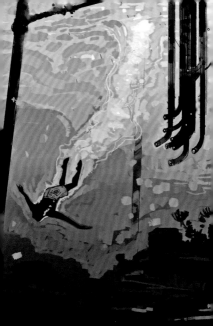

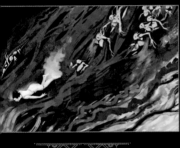

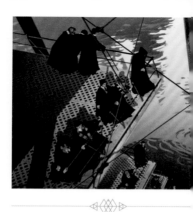

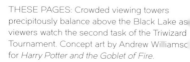

THESE PAGES: Crowded viewing towers precipitously balance above the Black Lake as viewers watch the second task of the Triwizard Tournament. Concept art by Andrew Williamson for *Harry Potter and the Goblet of Fire*.

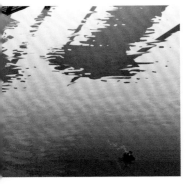

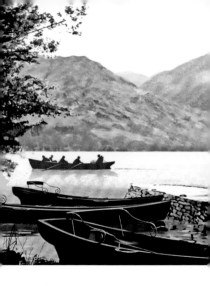

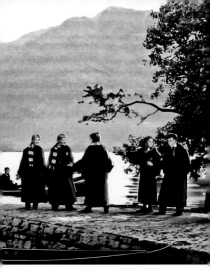

THESE PAGES: A view of the Black Lake from
boat dock, created by Andrew Williamson for
Goblet of Fire.

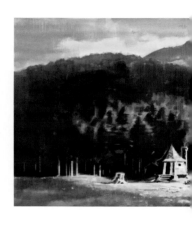

HAGRID'S HUT

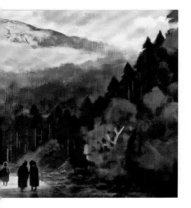

THESE PAGES: Harry, Ron, and Hermione visit
Hagrid's hut many times throughout the films.
Concept art by Adam Brockbank for *Harry Potter
and the Chamber of Secrets.*

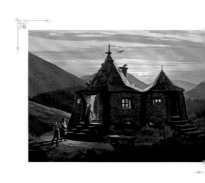

THESE PAGES: The hut acquired a second
room in *Harry Potter and the Prisoner of Azka*
as depicted by Adam Brockbank (*above*) and
Andrew Williamson (*right*), who also painted a
view of Harry, Ron, and Hermione watching
Buckbeak's fate being determined.

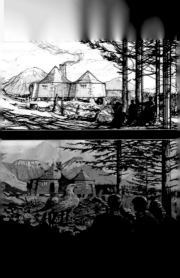

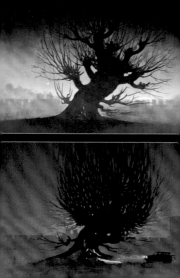

THE WHOMPING WILLOW

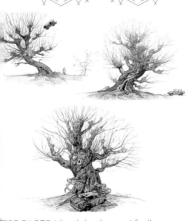

THESE PAGES: Visual development for the Whomping Willow by Dermot Power for *Harry Potter and the Chamber of Secrets*.

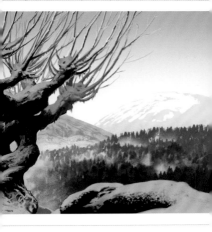

THESE PAGES: The Whomping Willow in winter by Adam Brockbank for *Harry Potter and the Prisoner of Azkaban*.

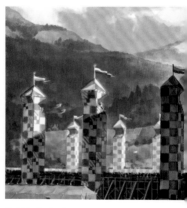

Quidditch, the favorite sport of wizards and witches, incited thrilling rivalries between the houses of Hogwarts.

THE QUIDDITCH PITCH

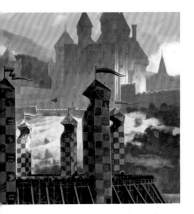

THESE PAGES: Adam Brockbank depicts the Quidditch Pitch in art for *Harry Potter and the Chamber of Secrets*.

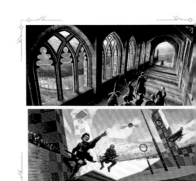

TOP: The Gryffindor Quidditch team unknowingly heads for a game that has been canceled in concept art by Andrew Williamson, for a scene for *Harry Potter and the Order of the Phoenix* that did not make it in the final film.

ABOVE: Seekers Harry Potter and Draco Malfoy race after the Golden Snitch in *Harry Potter and the Chamber of Secrets*. Art by Adam Brockbank.

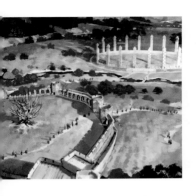

ᴏᴠᴇ: Dermot Power placed the Quidditch
h right next to a meandering river—not it's actual
graphy—for *Harry Potter and the Chamber of*
rets.

ESE PAGES: A view of the Quidditch Pitch
n the Owlery, created by Andrew Williamson
Harry Potter and the Goblet of Fire.

The Triwizard Tournament comes to Hogwarts in *Harry Potter and the Goblet of Fire*, bringing with it two rival schools, Durmstrang Institute and Beauxbatons Academy of Magic.

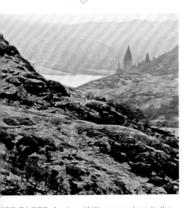

ESE PAGES: Andrew Williamson depicts the
a where the first task took place.

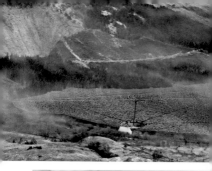

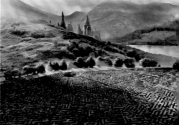

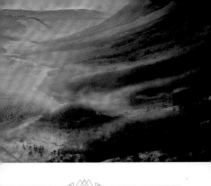

PAGES 210–213: Art by Andrew Williamson showing the exterior and interior of the maze created for the third task of the Triwizard Tournament.

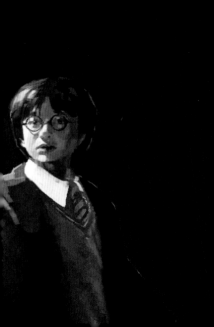

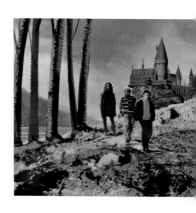

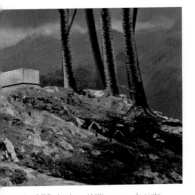

ESE PAGES: Andrew Williamson depicts
ry, Ron, and Hermione next to Professor
mbledore's tomb on an island in a scene
Harry Potter and the Half-Blood Prince. This
ne did not make it into the final film.

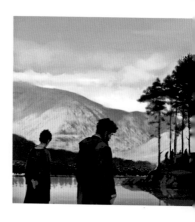

THESE PAGES: Adam Brockbank shows different views of Albus Dumbledore's burial near the Black Lake for *Harry Potter and the Half-Blood Prince*. This scene was not filmed f the movie.

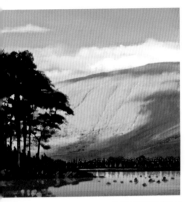

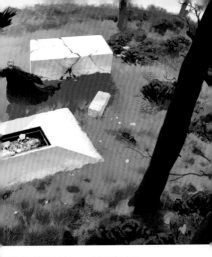

THESE PAGES: Voldemort breaks into Dumbledore's tomb to retrieve the Elder Wand. Art by Adam Brockbank for *Harry Potter and the Deathly Hallows – Part 1*.

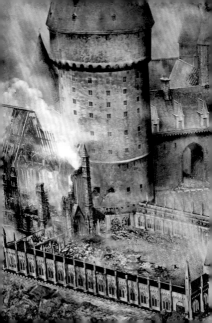

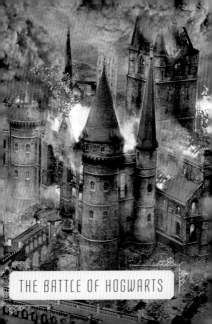

THE BATTLE OF HOGWARTS

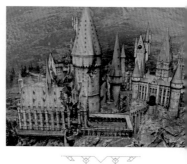

PAGES 220–223: Andrew Williamson depicts Hogwarts castle under attack during the Battle of Hogwarts in *Harry Potter and the Deathly Hallows: Part 2*.

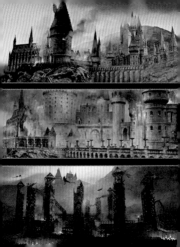

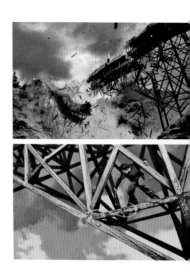

ABOVE: Adam Brockbank depicts the destruction of Hogwarts' covered bridge.

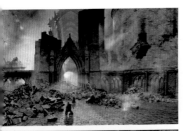

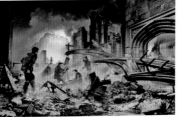

ABOVE: Andrew Williamson pictures various scenes in Hogwarts' decimated courtyard.

ABOVE: Death Eater armor by Adam Brockbank for *Harry Potter and the Deathly Hallows – Part*

OPPOSITE: The fighting knights of Hogwarts castle by Adam Brockbank. The knights are brought to life when Professor McGonagall casts the spell *Piertotum Locomotor* in *Harry Potter and the Deathly Hallows – Part 2*.

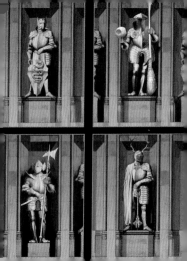

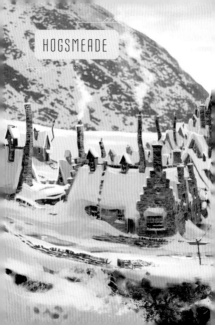

HOGSMEADE

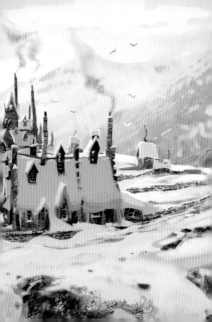

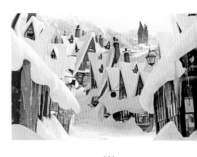

PAGES 228–235: Andrew Williamson paints a
sketches various views of the wizarding village
of Hogsmeade, which is perpetually above the
snowline.

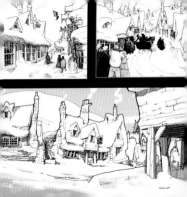

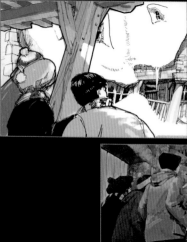

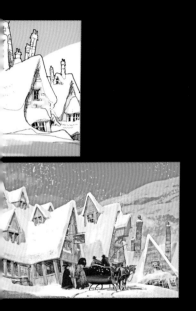

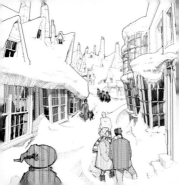

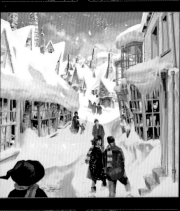

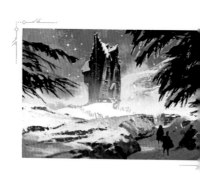

ABOVE: Ron and Hermione walk toward the Shrieking Shack, the most haunted building in England, by Adam Brockbank for *Harry Potter and the Prisoner of Azkaban*.

OPPOSITE: Dermot Power presents a different though still snowy, view of Hogsmeade.

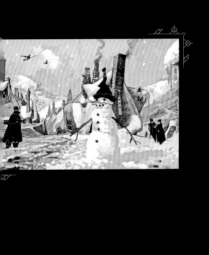

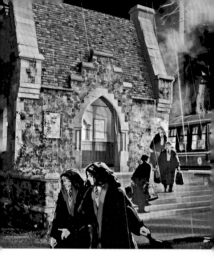

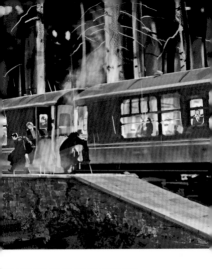

THESE PAGES: Students disembark at Hogsmeade station, by Andrew Williamson for *Harry Potter and the Order of the Phoenix*.

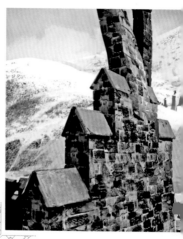

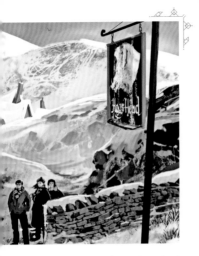

ESE PAGES: Harry, Ron, and Hermione about
nter the Hog's Head, where they will form
mbledore's Army. Concept art for *Harry Potter*
the Order of the Phoenix.

241

THESE PAGES: The Hog's Head's namesake
Art by Rob Bliss.

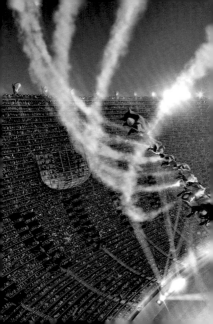

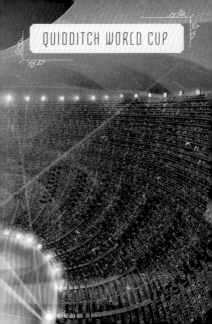

QUIDDITCH WORLD CUP

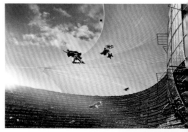

PAGES 244–247:
Andrew Williamson illustrates the best views above the stadium hosting the 422nd Quidditch World Cup, as seen in *Harry Potter and the Goblet of Fire*.

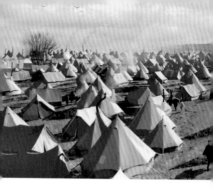

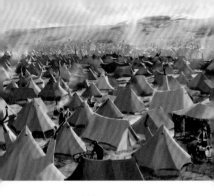

ESE PAGES: The campground beside the
idditch World Cup arena. Artwork by Andrew
liamson for *Goblet of Fire*.

249

ESE PAGES: Voldemort's Death Eaters
ade the camp at night, burning the tents and
ting the *Morsmordre* Spell, conjuring the Dark
rk in the sky. Art by Andrew Williamson.

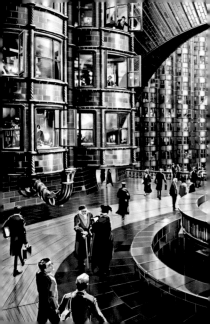

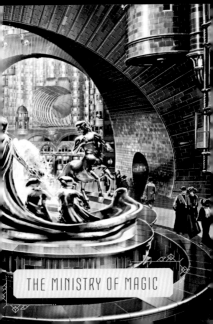

THE MINISTRY OF MAGIC

THE ATRIUM

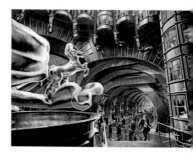

PAGES 252–254: The Atrium of the Ministry of Magic, featuring the Fountain of Magical Brethre[n] painted by Andrew Williamson as first seen in H[arry] Potter and the Order of the Phoenix.

OPPOSITE: A closer view of the wizard, who flo[ats] above his pedestal here, by Adam Brockbank.

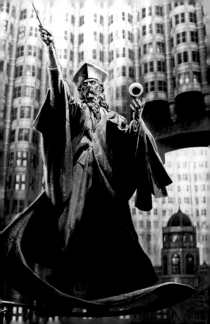

THESE PAGES: The Ministry of Magic
courtroom, as first seen by Harry in the Pensie

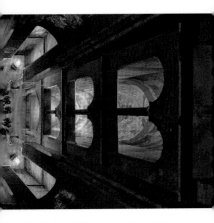

strated by Andrew Williamson for *Harry Potter*
the *Goblet of Fire.*

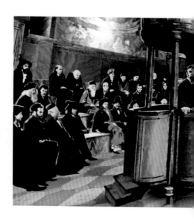

ABOVE: Harry gets a closer view of the trial of th[e]
Death Eaters in *Harry Potter and the Goblet of F*[...]

RIGHT: Harry finds himself on trial in *Harry*
Potter and the Order of the Phoenix, by Andrew
Williamson.

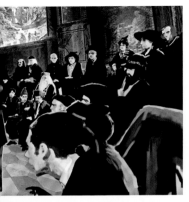

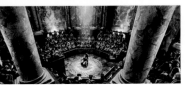

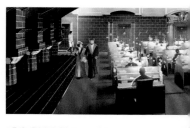

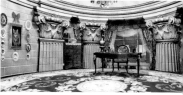

MUGGLE-BORN REGISTRATION COMMISSION

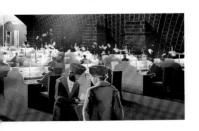

ABOVE: Office of the Muggle-Born Registration Commission, as supervised by Dolores Umbridge. Concept art by Andrew Williamson for *Harry Potter and the Deathly Hallows – Part 1*.

LEFT: Umbridge's office at the Ministry with her familiar kitten plates on pink walls, in Andrew Williamson's depiction for *Harry Potter and the Deathly Hallows – Part 1*.

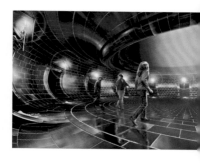

THESE PAGES: The entrance to the Department of Mysteries, by Andrew Williamson for *Harry Potter and the Order of the Phoenix.*

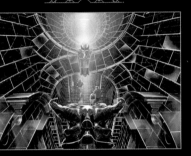

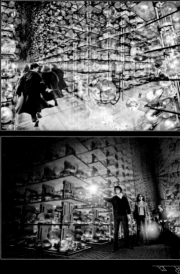

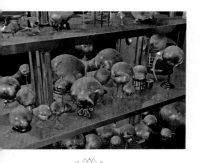

PAGES 264–267: In *Harry Potter and the Order of the Phoenix*, Harry and his friends explore the Hall of Prophecy at the Department of Mysteries in the Ministry of Magic. Andrew Williamson shows the many shelves of orbs in his concept art.

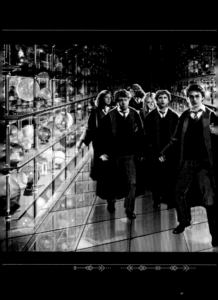

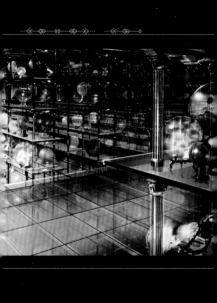

ABOVE: Adam Brockbank's concept art portrayi
Dumbledore's Army creating a Patronus shield i
the Death Chamber for *Order of the Phoenix*. Th
scene did not occur in the film.

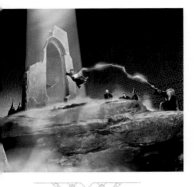

ABOVE: Andrew Williamson shows the moment when Bellatrix Lestrange casts the *Avada Kedavra* curse at Sirius Black, sending him through the Veil, in *Order of the Phoenix*.

WIZARDING PRISONS

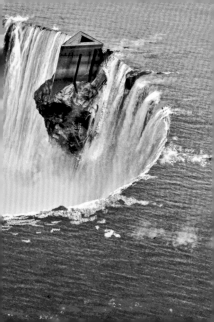

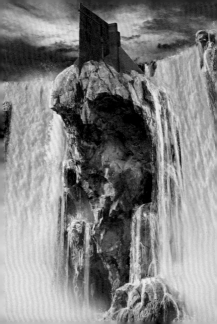

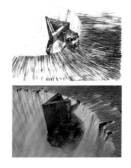

GES 270–273: Andrew Williamson depicts
kaban on an island in a stormy sea.

OVE: The first sketch of Azkaban prison by
duction designer Stuart Craig for *Harry Potter*
d the Order of the Phoenix (*top*) and a painting by
drew Williamson following the design (*bottom*).

NURMENGARD

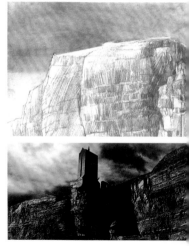

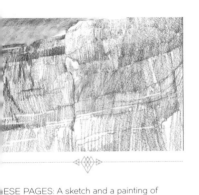

<div style="text-align:center">◆◈◆</div>

ESE PAGES: A sketch and a painting of
rmengard prison, where Gellert Grindelwald
s imprisoned and where Voldemort tortured
n for information about the Elder Wand, as
en in *Harry Potter and the Deathly Hallows –*
t 2.

△▽△

THESE PAGES: In *Harry Potter and the Half-Blood Prince*, Harry and Professor Dumbledore travel to a remote cave to retrieve one of Voldemort's Horcruxes. Visual development for this location by Andrew Williamson.

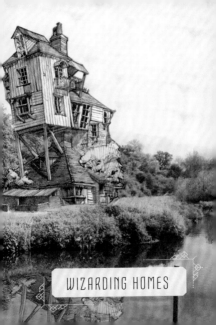

WIZARDING HOMES

THE BURROW

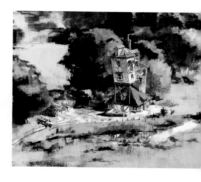

PAGES 278-280: Andrew Williamson illustrates the flying Ford Anglia at The Burrow for *Harry Potter and the Chamber of Secrets.*

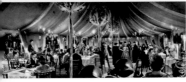

TOP: Andrew Williamson portrays Molly Weasley out to confront her sons about taking their father's car in *Chamber of Secrets*.

ABOVE: The wedding of Bill Weasley and Fleur Delacour took place in a covered tent in the garden of The Burrow. Art by Andrew Williamson for *Harry Potter and the Deathly Hallows – Part 2*.

THESE PAGES: Andrew Williamson depicts The Burrow under attack by Death Eaters in *Harry Potter and the Half-Blood Prince*.

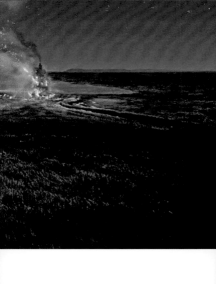

NUMBER TWELVE, GRIMMAULD PLACE

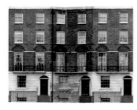

ABOVE: The façade of Grimmauld Place opens up to reveal Number Twelve, as detailed by Andrew Williamson.

OPPOSITE TOP: Number Twelve, Grimmauld Place, the ancestral home of the House of Black, as painted by Andrew Williamson for *Harry Potter and the Order of the Phoenix.*

OPPOSITE BOTTOM: The Weasley family spend Christmas at Sirius's home. Art by Adam Brockbank.

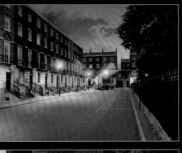

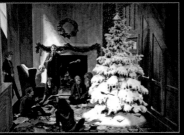

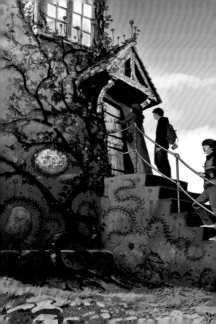

LOVEGOOD HOUSE

OPPOSITE: Hermione, Harry, and Ron approach
the Lovegood house for help, as seen in *Harry
Potter and the Deathly Hallows – Part 1*.

TOP: A sketch by Stuart Craig of the Lovegood
house, noted for resembling a rook chess piece.

ABOVE: Adam Brockbank depicts the house
perched on its hill with kites flying above it.

MALFOY MANOR

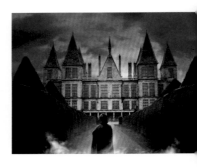

ABOVE: Severus Snape stands before Malfoy Manor in *Harry Potter and the Deathly Hallows - Part 2*. Concept art by Andrew Williamson.

OPPOSITE: Inside the dining hall of Malfoy Manor, where Charity Burbage hangs above Voldemort and his Death Eaters. Art by Andrew Williamson.

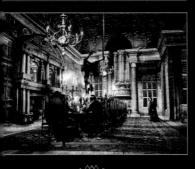

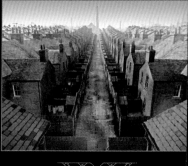

SPINNER'S END

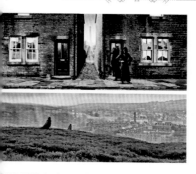

OPPOSITE: Andrew Williamson depicts the weary village of Spinner's End, home of Severus Snape in *Harry Potter and the Half-Blood Prince*.

ABOVE: Sisters Narcissa Malfoy and Bellatrix Lestrange travel to Spinner's End to see Professor Snape in two pieces created by Andrew Williamson for *Half-Blood Prince*.

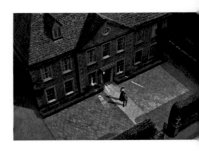

THESE PAGES: In *Harry Potter and the Half-Blood Prince*, Harry and Professor Dumbledore travel to the village of Budleigh Babberton to convince Horace Slughorn to return to his teaching position at Hogwarts. Art by Andrew Williamson.

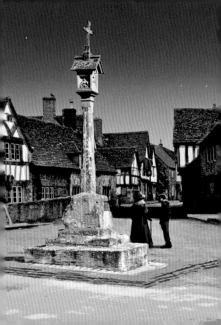

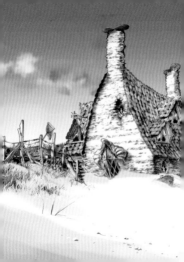

SHELL COTTAGE

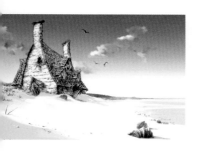

THESE PAGES: Two sketches of Shell Cottage
by Andrew Williamson for *Harry Potter and the
Deathly Hallows – Part 2.*

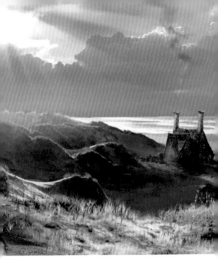

THESE PAGES: Dobby's grave sits on a hill above Shell Cottage. Art by Andrew Williamson for *Harry Potter and the Deathly Hallows – Part 2*

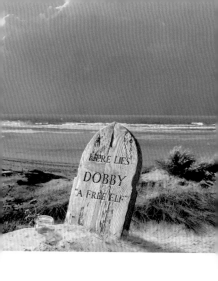

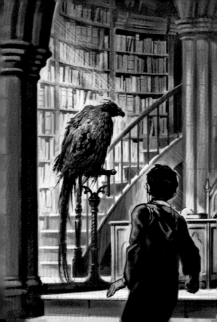

CONCLUSION

From the soaring towers of Hogwarts to the gravity-defying lean of Diagon Alley, the concept art for each mysterious location featured in the Harry Potter films explored fascinating ways to infuse the films' settings with magic. Of course, as the series progressed, the design for the sets often evolved as well. Popular

OPPOSITE: Harry Potter discovers Dumbledore's phoenix, Fawkes, on a Burning Day in concept art by Adam Brockbank for *Harry Potter and the Chamber of Secrets*.

settings, such as the Great Hall and the Dark Arts classroom, were frequently redressed for special celebrations, changes of season, and new inhabitants, which helped to keep familiar locations feeling fresh and exciting. Even the iconic exterior of Hogwarts itself gained a few new towers over the course of the series.

"They've been changed for no better reason than that it would just be nice to improve on them," says production designer Stuart Craig, noting that this is "part of the ongoing magical regeneration, from one film to another."

OPPOSITE: Artwork by Andrew Williamson for *Harry Potter and the Order of the Phoenix*.

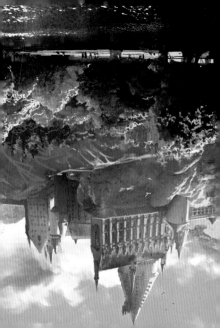

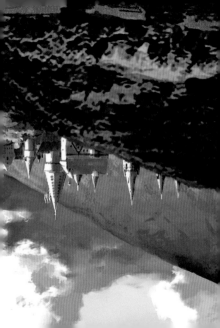

...hat regeneration continues with a ...w series of films based on *Fantastic ...easts and Where to Find Them*. Written ...J.K. Rowling herself, and featuring the ...ents of both Craig and veteran *Harry ...otter* director David Yates, this series ...troduces a whole new generation ...wizards, but features a few key set ...eces that will be familiar to filmgoers.

...seems fans haven't yet taken their last ...p to Hogwarts!

...PPOSITE: Concept art of a view of Hogwarts ...stle by Adam Brockbank to suggest a possible ...al shot for *Harry Potter and the Goblet of Fire*.

INSIGHT
EDITIONS

PO Box 3088
San Rafael, CA 94912
www.insighteditions.com

f Find us on Facebook: www.facebook.com/InsightEditions

y Follow us on Twitter: @insighteditions

All rights reserved. Published by Insight Editions, San Rafael,
California, in 2019.

Sections of this book were originally published in *The Art of
Harry Potter* by Insight Editions. San Rafael, CA, in 2017.

No part of this book may be reproduced in any form without
written permission from the publisher.

978-1-68383-751-0

Manufactured in China by Insight Editions

10 9 8 7 6 5 4